S0-BBS-438

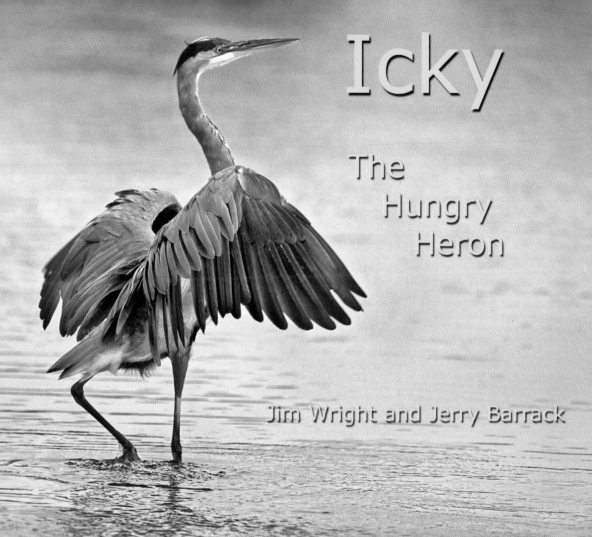

Icky

The
Hungry
Heron

Jim Wright and Jerry Barrack

In the Presence of Nature Books, Allendale, New Jersey

Once upon a secret lake
where very few humans went,
hungry birds called herons
did just what they were meant:

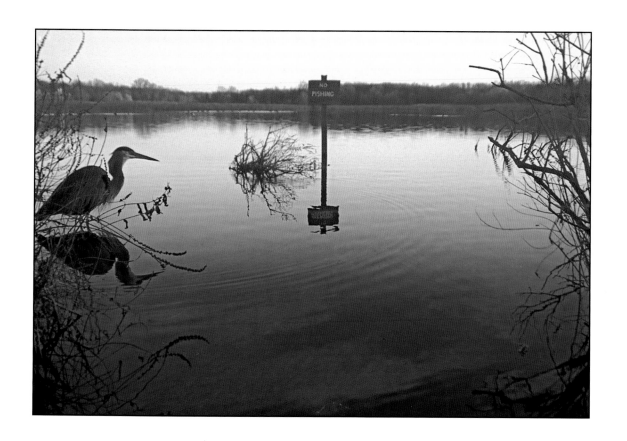

3

To catch fish!

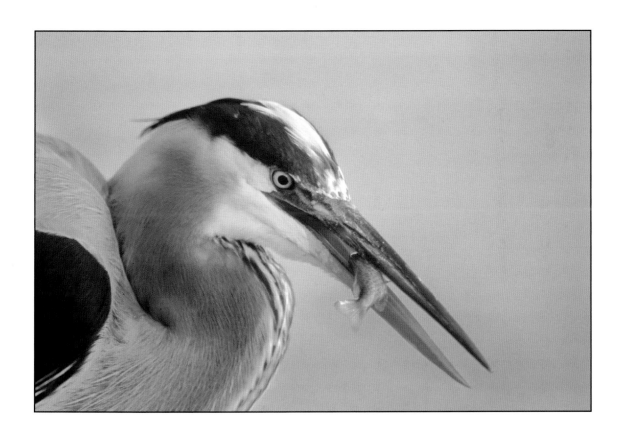

Their lanky legs were stilts
for standing statue still,
and as for their finny dinners,
they just put them on their bill.

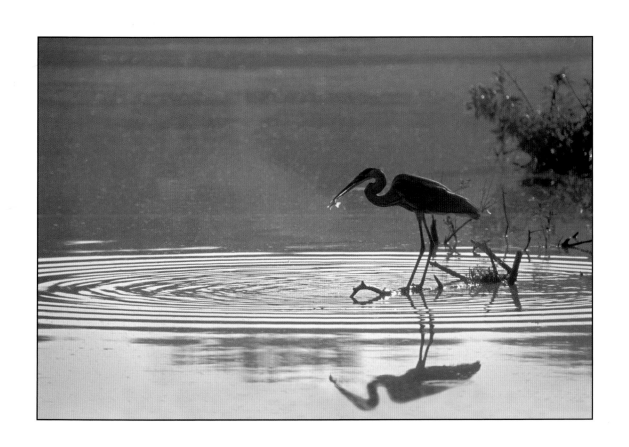

But even the greatest herons knew
that one fish couldn't be caught -
a giant carp called Mr. Big,
who was only food for thought.

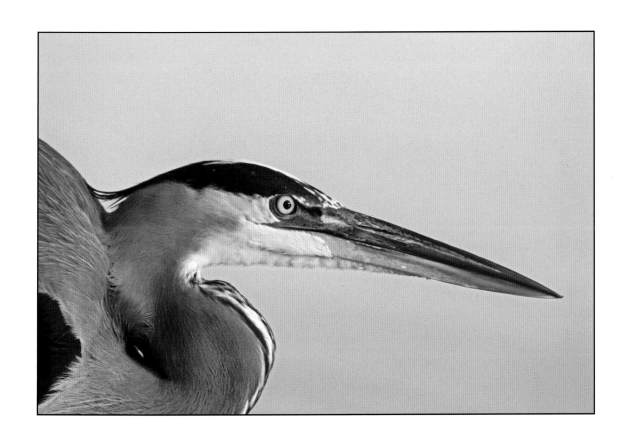

But young Ichabod Heron knew
he could catch that carp for sure.
If he practiced and practiced,
Mr. Big would become the fish du jour.

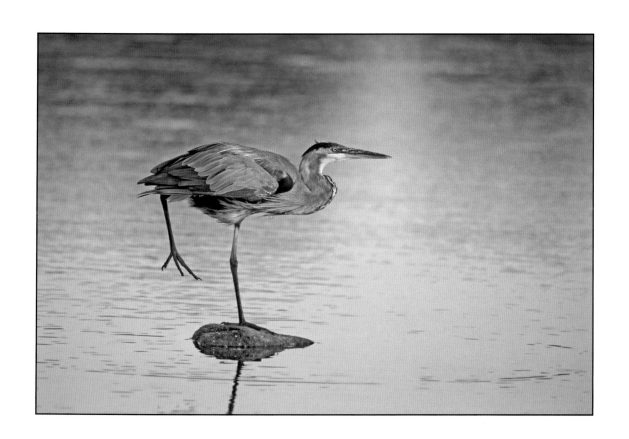

11

Some days Icky waved his wings,
soared high, and made a wish:
that a heron's eye view
would reveal a super-sized fish.

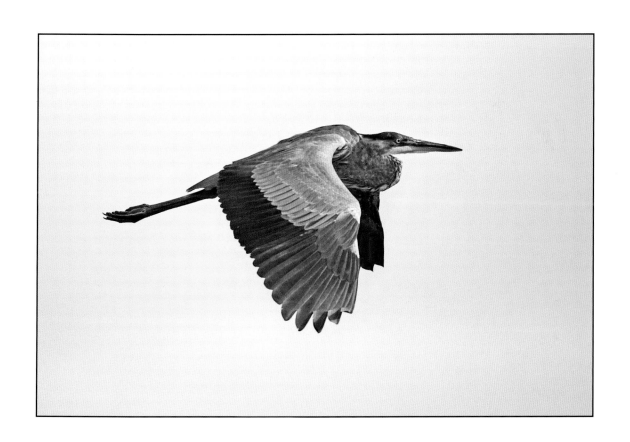

Some days he waited with baited breath,
hoping the brilliant Mr. Big
would mistake a skinny leg
for a stick or reed or twig.

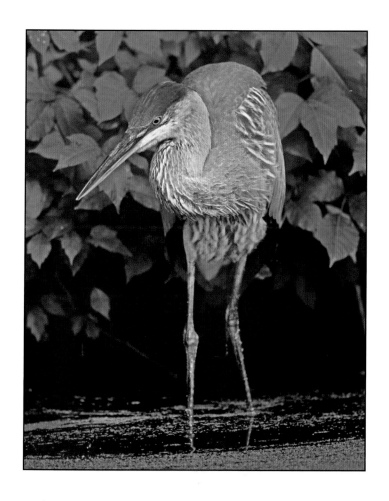

15

Then one morning, Icky spied him,
a fish a-fire, a bolt of light.
Icky crooked his neck
and thought, "*Bon* appetite."

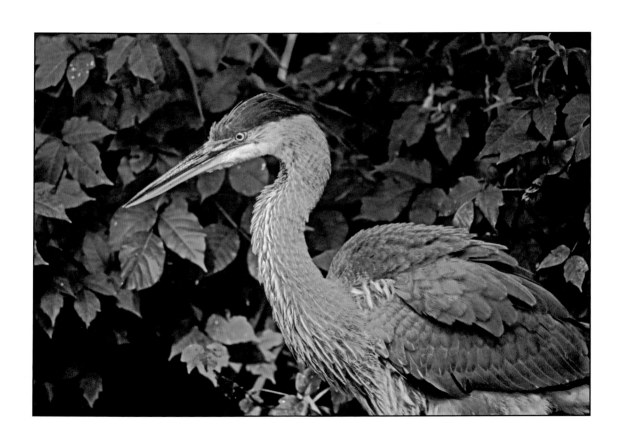

Whoosh. Splash. Success.
Mr. Big - the uncatchable Mr. Big -
had gone from Moby Fish
to a meal of *carp l'orange*.

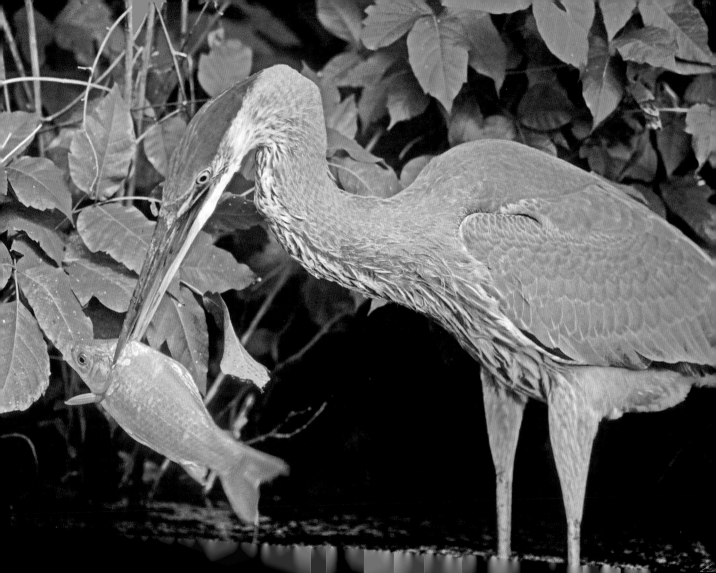

Not so fast. Mr. Big was too thick,
and Icky's throat was too thin.
He couldn't let this fish get away,
but he couldn't fit him in.

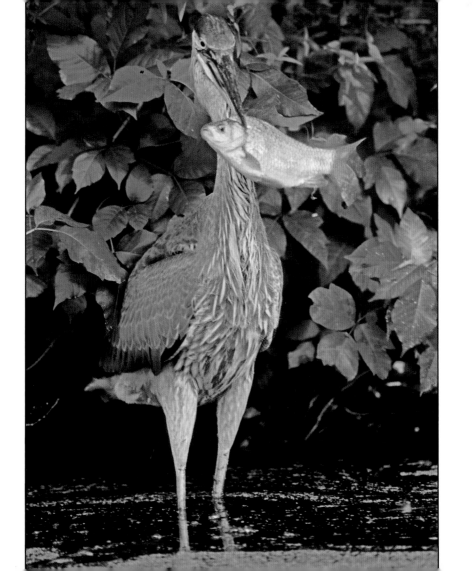

So Icky angled the fish,
and he dangled the fish.

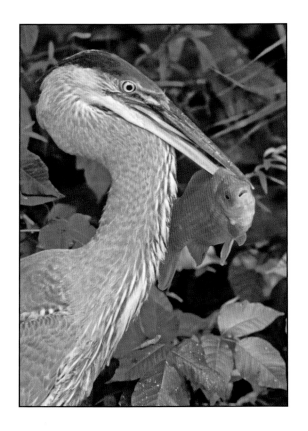

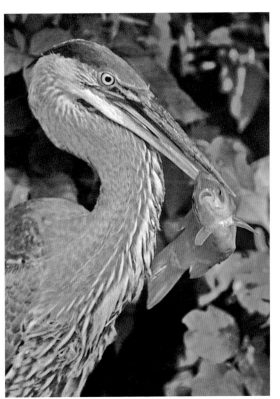

23

He opened wide, and tried and tried,
to force Mr. Big inside.

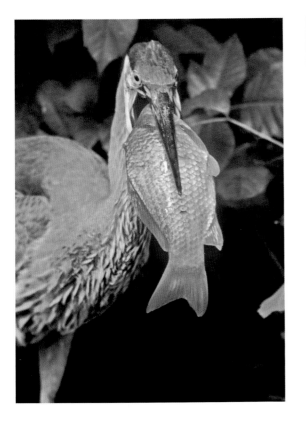

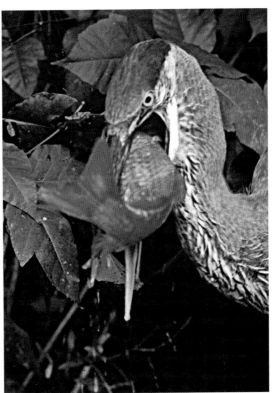

25

Icky gulped once – gulped twice –
and Mr. Big went all squooshy,
s-l-o-w-l-y sliding down Icky's gullet
to the land of instant sushi.

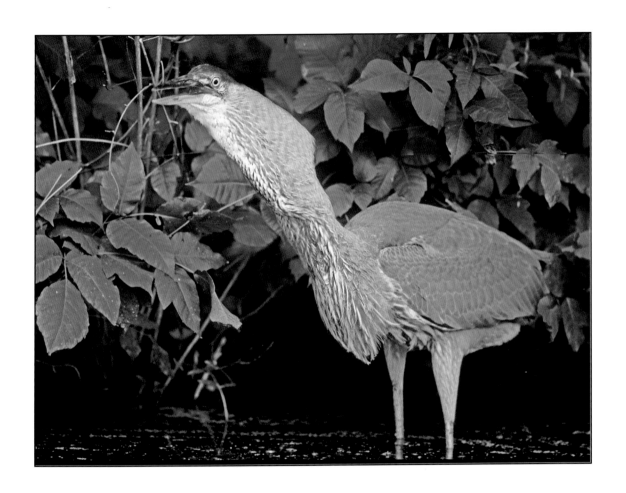

An older bird stood stunned,
then shouted out: Hooray!
"Great job, Icky my boy.
You just ate one big fish buffet!"

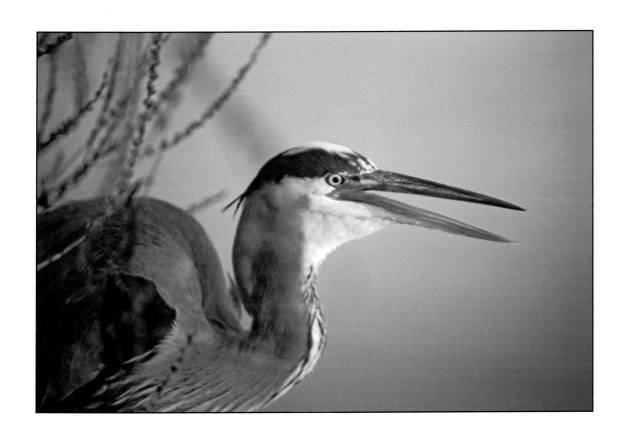

Icky's catch and his amazing tale
make a point you ought to follow.
Work hard, and dreams can come true,
even if some think they're hard to swallow.

Doesn't that put a lump
in your throat?

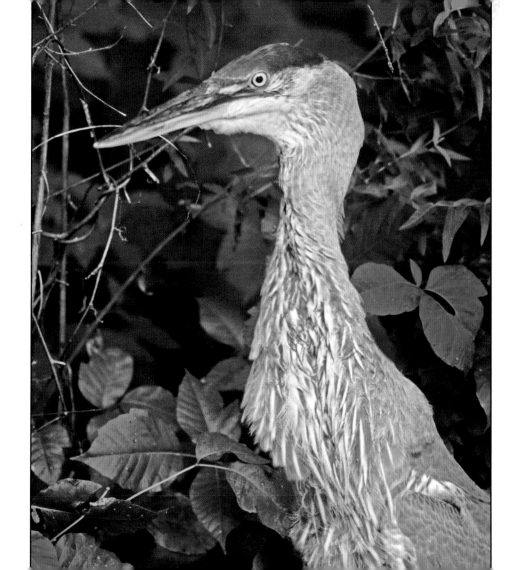

31

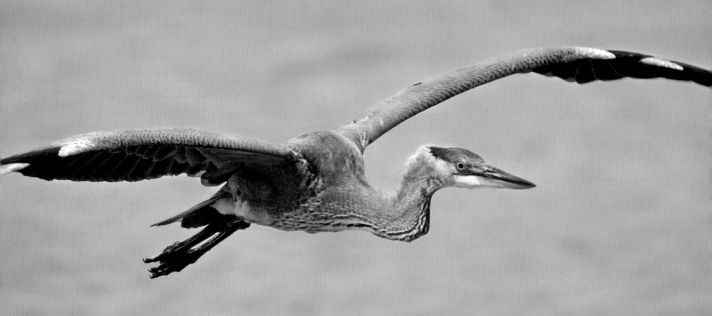

The End